Marion Post Wolcott:
Thoughts on Some Lesser Known FSA Photographs

by Sally Stein

Marion Post Wolcott is one of the small group of energetic photographers whose work for the U.S. Farm Security Administration resulted in the extraordinary pictorial archive that documents rural American life in the 1930s. The work of the FSA Historical Section is relatively well known, and recent studies of FSA photography have given great exposure to the project director, Roy Stryker, and to the photographs of Walker Evans and Dorothea Lange. Russell Lee, Arthur Rothstein and Ben Shahn have all received increasing consideration, whereas the work of other FSA photographers such as Jack Delano, Carl Mydans, John Vachon and Marion Post Wolcott has continued to be treated in a cursory manner.[1]

In his *Portrait of a Decade* (1972), the first book published on this New Deal documentary project, F. Jack Hurley characterized Post Wolcott as the atypical photographer hired by Stryker, a romantic "city girl" in a predominantly male group of seasoned social observers. Subsequent publications have not challenged that stereotype. The published selections from her FSA work have concentrated on a limited group of images of fertile farms and quiet New England towns.

As this publication makes clear, Post Wolcott's FSA work was hardly confined to these genres. Yet even when a more wide-ranging group of her photographs is reviewed, she still appears to be an anomalous member of the FSA, one whose distinctive interests constitute an unsentimental, provocative departure from the dominant themes of FSA photography.

What were the underlying thematic conventions of this collection of photographs which, after editing, amounted to well over seventy thousand prints? Thirty years after he left his New Deal post as chief of the FSA Historical Section, Stryker, in collaboration with Nancy Wood, published a personal survey of FSA photography with the sanguine title, *In This Proud Land.* In an introductory essay that generalized about the scope and unique value of the resulting archive, Stryker distilled the philosophical as well as pragmatic concerns that informed his management of FSA photographers and photographs.

> We provided some of the important material out of which histories of the period are being written. But you'll find no record of big people or big events in the collection. There are pictures that say labor and pictures that say capital and pictures that say Depression. But there are no pictures of sit-down strikes, no apple salesmen on street corners, not a single shot of Wall Street, and absolutely no celebrities.[2]

To a remarkable degree, the FSA collection of photographs conforms to these parameters. Among the best known, "classic" FSA images, one has to look extremely hard for any reference to "big men or big events." A few of Ben Shahn's early photographs make such allusions by directing attention to forms of power that repressed or channeled popular

discontent. I am thinking in particular of his image of a sheriff's ample rump, harnessed with hip holster and gun, *On duty during strike, Morgantown, West Virginia, 1935*.[3] Or of another rear-end view by Shahn, *Amite, Louisiana, 1935*,[4] which depicts two men conversing, one of whom holds behind his back a sheaf of Huey Long campaign posters.

Dorothea Lange's photograph *Plantation overseer and his field hands, Mississippi Delta, 1938*[5] has always stood apart from her and other FSA photographers' equally famous images because of the way it exemplifies some of the distinctions between these two classes of men. The difference most obvious in this photograph is that of skin color, but the contrast does not stop there. The overseer's clothes bear none of the signs of constant physical labor. Likewise, his build is much heavier than that of any of the assembled field hands. Just as importantly, the way he presents himself to the photographer within this heterogeneous grouping is singularly self-assertive. He wields power and appears to know it, and his field hands appear to know it, too.

These few examples notwithstanding, FSA photographers in general avoided seeking out regularly those juxtapositions that challenged the customary myths of American democracy: "the concept of the integrity of the individual; the concept of responsible leadership; the belief in self-government; the concept of individual liberty and of opportunity." [6] The salient exception is found in the work of Marion Post Wolcott.

This publication affords the first opportunity to study a broad sample of Post Wolcott's FSA photography. There is considerable diversity in this group of photographs, and by no means are all the images strongly polemical. She was, after all, working for the FSA, limited by Stryker's overriding objectives, greatly impressed by the power of the FSA photographs made before she began working for him in 1938, and deeply committed to the worth of the New Deal's reform efforts. Yet one cannot help noticing in her images the recurrent concern with such difficult and persistently divisive issues as class and race. These may sound like rhetorical issues that categorically reduce the nature of people and their experiences, but as a considerable number of Post Wolcott's photographs make evident, they bear profoundly on the most mundane, constant features of daily life.

Take, for example, the photograph she made looking down upon an outdoor Florida resort scene. *Winter visitor being served brunch at a private club in Miami, 1939* (PLATE 24) was done as a part of a series of photographs that contrasted the complacency of the affluent with the abject poverty she had documented in nearby migrant labor camps. Her studies of privileged resort life continued to consider the work involved in this other major Florida industry. As the title of this photograph indicates, the principle activity in this scene consists of one man serving another a multi-course meal. The light is intense; the weather is hot. The man in the deck chair has unbuttoned his shirt, and other chairs at the edge of the frame are draped with unnecessary garments. The waiter, however, is suited-up. The tan line at his wrists indicates that he has spent a lot of time serving outdoors in this uniform. Except for the fact that both men are white, few individual characteristics are discernible, including even their respective ages. The waiter is balding, but the hotel guest may be wearing a hat to protect a similarly balding head from the sun. This frustration at being unable to "read" these men's faces leads to another observation, that of the lack of direct contact between the two figures. The exercise of discretion was a considerable part of the service work documented in this photograph.

MARION POST WOLCOTT

FSA Photographs

Introduction by Sally Stein

This book is dedicated to my husband, Lee Wolcott, and to my friend and fellow photographer, Ralph Steiner. My deepest gratitude to photographer Jack Welpott, for his advice, his help, and the loan of his darkroom. Also, my thanks to Sally Stein, for her assistance in locating the images reproduced here.

Preface & Acknowledgements

The Farm Security Administration photographic project that documented rural America during the great depression has had a forceful and lasting impact on our lives. Because of the considerable number of memorable images generated by the FSA photographers, they themselves have become heroes of the history of photography. While several photographic anthologies about the project have been printed, it is surprising that only a few of the talented FSA photographers have been published in monograph form.

Marion Post Wolcott is one of those whose work has not been seen, and this book provides the first opportunity to view a comprehensive group of her photographs outside the Library of Congress, the archive where all the FSA photographs and negatives are held. Post Wolcott joined the FSA project late in its evolution, at a time when signs of America's changing fortune were visible. With the economy beginning to prosper again, Post Wolcott's role in the FSA was to document the improving conditions of American life, as well as the continuing hardships of the Depression.

The essay that introduces Post Wolcott's photographs is unusual in that, rather than giving an overview of her work, it examines specific pictures in a socio-political context. An extensive chronology of Post Wolcott's life and work with the FSA complements the essay with important biographical information, and includes excerpts from letters written between the photographer and her director, Roy Stryker.

I would like to thank Marion Post Wolcott for her generosity and willingness to allow us to publish these important photographs. Her husband, Lee, has been most helpful in sorting out the thousands of details encountered in a project such as this. Sally Stein has contributed a most useful essay, one whose concerns will lead to a clearer realization of the uses of photography and of the medium's impact on society. I would also like to thank the kind people of the Library of Congress Farm Security Administration archive for their help with this project. On The Friends' staff, David Featherstone expertly coordinated the editorial process, Claire Peeps organized the chronology, and Peter Andersen contributed a handsome design. Thanks also go to David Gardner and the fine printers and engravers at Gardner/Fulmer Lithograph who reproduce photographs with such remarkable fidelity.

James Alinder, *Editor*

© 1983, The Friends of Photography
Photographs © 1983, Marion Post Wolcott
Introduction © 1983, Sally Stein

ISSN 0163-7916; ISBN 0-933286-38-4
Library of Congress Catalogue No. 83-81931

Untitled 34: This volume is the thirty-fourth in a series of publications on serious photography by The Friends of Photography. Some previous issues are still available.

Cover: *Migrant family from Missouri, Belle Glade, Florida, 1939.*
 "We ain't never lived like hogs before, but we sure does now."
Back Cover: *Post Office, Aspen, Colorado, 1941.*

Designed by Peter A. Andersen

The prohibition against direct contact between classes is the pointed subject of another photograph by Post Wolcott, *Business managers paying off cotton pickers, Marcella Plantation, Mileston, Mississippi, 1939* (PLATE 8). The title indicates that a group of cotton pickers are waiting to be paid, but the photographer's chosen vantage point behind the managers allows us to see only one, and that one only barely. The cotton picker's hand is framed not in the intimate, close-up style of Lange's *Hoe culture,*[7] a style that suggests the essential dignity of physical toil. The hand in this image is truncated more literally by the wood and wire barrier that serves to guard the managers and the money. All evidence indicates that this plantation was run on strict business principles; there is nothing personable about the rural relations depicted. The picker was not even handed her pay. Instead, it was set down a few inches away from the narrow window, and she had to cram her hand through this opening in order to obtain her wages. The amount of her pay is not indicated, but there is little doubt that it was as demeaning as the way it was delivered to her. The 1938 Fair Labor Standards Act, like the earlier NRA wages and hours codes, did not apply to most agricultural workers.

Another group also left unprotected by the labor legislation of the period was domestic workers. Nearly two million women were thus employed in the Depression, and of them, nearly half were black. Faced with fewer job options, black domestics as a rule worked longer hours for lower wages. On this basis, a March 1938 *Fortune* article recommended them as the least troublesome servant group. These people do not appear frequently in the FSA photographs. They were not mentioned in any of the general shooting scripts in which Stryker listed the subjects he wanted his photographers to seek out, but one publication project to which the FSA contributed did require some documentation of domestic workers. The 1941 book *12 Million Black Voices,* which combined an extended essay by Richard Wright with FSA photographs selected and edited by Edwin Rosskam, included two images of black domestic workers. The first, a photograph by Jack Delano, is a fairly close shot of the back of a uniformed woman on her knees scrubbing a stairway; the second image, by Marion Post Wolcott, depicting a less back-breaking chore, shows a uniformed domestic worker serving a meal to a blond child in a high chair. In this image as well as in another picture reproduced in the book, *Sharecropper negotiating price of his own cotton with cotton broker, Clarksdale, Mississippi, 1939* (PLATE 9), Post Wolcott made a point of indicating the way economic transactions between blacks and whites tended to reinforce the subordinate social status of blacks.

The FSA archive contains another photograph of domestic workers by Post Wolcott that was not reproduced in *12 Million Black Voices.* The omission is regrettable, for it is a more forceful image than the one included, and it would have worked especially well with Wright's text, which stressed the common problems faced by black Americans. Like all photographs, *Two colored maids on a street corner with a white child in a stroller, Port Gibson, Mississippi, 1940* (PLATE 33), is about a particular time and place and cast of characters, but it also makes uncommon demands upon the viewer to think in more general social terms. The grouping in the foreground of the photograph is formally symmetrical yet socially assymetrical. If another white child were present in the scene, we would quickly summarize the contents to be "two maids with their charges." As it is, the picture is less easily disposed of, for the *particular* relationships presented are not so readily sorted out.

Even though the two women focus on the same child, it is unlikely that both are employed to care for this child. More likely, they work for separate households in the same tree-lined, residential neighborhood. This explanation serves only generally, however. It does not clarify which uniformed woman has responsibility for this child, and it does not dispel the immediate suggestion of a *surplus* of black women concentrated in domestic work, easily replaced and therefore easily exploited. Another feature of this image points to the subjective effect of being part of a marginal economic class. Although only one of these women probably takes care of the child, both women, in the presence of an unfamiliar white photographer, assume that their own presentation to the camera is of less importance than the presentation of the child.

Post Wolcott's photographs often incorporated details such as these that first appear to be incidental and then become, the longer one looks, significant features of the scene described. Few of her photographs attained the status of icons, as did such images as Lange's *Migrant Mother* or Rothstein's *Dust storm, Oklahoma,* but it is clear from her FSA letters that Post Wolcott was after something else, something less monumental and more complex. Writing to Stryker from rural Florida on February 3, 1939, she astutely observed that the government documentary project might be improved if it adopted a broader conception of the way work was actually experienced.

> *... there are many things to photograph around the packing houses which give as good a picture of [the workers'] lousy existence & general life & health etc., as around their houses and shacks. I don't remember that we have much of this. I don't mean just showing the packing and grading process. I mean the life of the packing house—the hanging around, the "messing around," the gambling, the fighting, the "sanitary" conditions, the effects of the very long work stretch, the rest periods, their "lunch", etc.[9]*

When detailing what she meant by "the life of the packing house," she began with the "hanging around." This was an inescapable feature of the lives of casual laborers who depended upon an unpredictable harvest; in a bad season such as 1939, it could mean waiting around all day for a few minutes of paid work. However, the importance she attached to "hanging around" was not confined to the situation of the packing house. Though Post Wolcott contributed a fair share of the physiognomic, architectural and agricultural records that comprise the bulk of the FSA file, she was especially attentive to informal group interactions for the way they expressed some of the bonds and boundaries within a community. This interest precluded the common pictorial strategy of moving in close; and as a result, much of her imagery studying group dynamics is less sensationally dramatic. Hers are rather cool observations which document not only the character of people's gestures but also the general environment and specific objects that gave rise to these forms of non-verbal communication.

Consider her picture of sidewalk activity in one Southern town. The scene is relatively quiet, though not so uneventful as its title suggests—*An advertisement on the side of a drugstore, Wendell, North Carolina, November, 1939.* (PLATE 7). That quite conventional FSA subject matter may have inspired the photographer to set up her view camera, but this particular photograph was not made in response to that ad. When Post Wolcott made her exposure, a number of figures were positioned between the camera and ad so that the ad's

message became unreadable. Instead, another message was conveyed by the momentary configuration of pedestrians. Among them, the most firmly planted and solidly built is a white man, comfortably dressed, who seems to stare, perhaps suspiciously, at the photographer across the street. A white woman is passing by, clutching either a parcel or a small infant. Two black men, dressed in overalls, are moving at a rapid gait from the opposite direction. They move in single file, cutting the widest arc so as to avoid close contact with either the woman or the stationary man.

More than the previous photographs I have referred to, this one is quite ambiguous. The racial tension evidenced is subtle; no rights are being deprived. These two black men are merely altering their paths in the face of other, white pedestrians. The accommodation is minor, but the observation on social behavior in mixed racial groups is still noteworthy. If there were any pattern to this documented behavior, it would have to be considered as an act of deference performed regularly in public, to avoid any suggestion of an affront, especially in relation to a white woman.

There was, of course, a pattern to such behavior, though FSA photographers rarely subjected it to close scrutiny. While numerous well known photographs in the FSA file refer explicitly to racism, they do so most often through the depiction of public signs; signs that either resorted to extreme racial caricature or delineated the segregation of public facilities. In effect, these are representations of artifacts, removed from actual behavior, and as such are easily studied in symbolic rather than experiential terms. Images of this kind do appear in Post Wolcott's work (PLATE 19), made in response to the subjects listed in Stryker's shooting scripts. In marked contrast, *Wendell, North Carolina* contends with the way racial codes were played out in the conduct of daily life. Moreover, the photograph identifies the point of greatest potential conflict within this social situation, the point where racial codes intersected with sexual codes. This insight was especially provocative insofar as it resulted from the observation of one white woman on the defensive measures occasioned by the presence of another white woman.

While such concerns were not generally evident in FSA photography, it would be incorrect to assume that they were not topical issues in the 1930s. Stryker himself had raised them when he first offered Marion Post a job in 1938. (Her name was Marion Post until her marriage to Lee Wolcott in 1941.) In the July 1938 letter that outlined the terms of her employment, Stryker made clear that he considered her status as a single woman to be a considerable liability, particularly with regards to her working in the South.

> *There is another thing I raised with you the other day, that is the idea of your traveling in certain areas alone. I know that you have a great deal of experience in the field, and that you are quite competent to take care of yourself, but I do have grave doubts of the advisability of sending you, for instance, into certain sections of the South. It would not involve you personally in the least, but, for example, negro people are put in a very difficult spot when white women attempt to interview or photograph them. But I do not think this needs be a serious consideration at this moment. There are plenty of things to be done in the various problem areas of this country.*

Stryker soon abandoned his plan of keeping Post Wolcott away from the South. Paradoxically, he ended up assigning her to photograph primarily in that region during the three

and a half years she worked for the FSA. Once she began working in the field, she must have quickly convinced her boss that she knew how to avoid causing trouble for herself or others. Her FSA letters provided a running, witty commentary on the time wasted in observing the customs of the region. These letters probably reassured Stryker that she appreciated the need for discretion as well as he did. Whatever the reason Stryker altered his original plan, however, we should not underestimate the importance of the problem he had initially raised. Particularly in 1938, it was a problem that had assumed the proportions of a major political controversy.

Throughout the 1930s, the NAACP had lobbied Washington politicians to support federal anti-lynching legislation. After numerous delays and many additional lynchings, a bill was introduced in the House of Representatives in April 1937. The bill seemed assured of victory when a vote passed the House by a margin of 277 to 120. The overwhelming support expressed in the House was partly due to timing, since the bill reached the floor two days after a Mississippi mob had resorted to new forms of torture, using a blow torch in one of eight lynchings recorded for that year. The Senate proved less responsive to this incident. A Senate vote was postponed twice in 1937, and the third attempt to introduce the bill in January 1938 resulted in a six-week long filibuster that succeeded in killing this legislation. As the historian George Tindall noted in *The Emergence of the New South*, "throughout the controversy Roosevelt kept aloof."[10] The demise of the anti-lynching bill thereby signalled the limits of the New Deal's commitment to black Americans.

While the Roosevelt Administration leadership declined to take a stand that was bound to alienate a sizable number of Southern Democrats who were an essential part of the New Deal coalition, there were an increasing number of whites as well as blacks who voiced their opposition to this extreme form of white supremacy. Especially prominent in a diverse anti-lynching movement was the Association of Southern Women for the Prevention of Lynching, which numbered by 1939 nearly 40,000 members who objected strenuously to the way "mobsters claimed to be acting in defense of [white] womanhood."[11] In other words, Post Wolcott's *Wendell, North Carolina* photograph was made at a time when a small but well-publicized group of white women was adopting a strong critical stand against the way they traditionally served as pawns for violent crimes by white men against black men.

Without question, this photograph documents no crime per se. Its subject was a daily encounter, undramatic in and of itself, but a potential pretext for more dramatic events; the kind of mundane subject that was presumably the abiding concern of documentary, as opposed to journalistic photography. If the record of the event allowed for open-ended interpretation, so did the event itself. The psychologist John Dollard described in this way the latent menace present in the most ordinary situations which confronted Southern black men.

> *The terrifying fact is that lynchings not only do occasionally occur but may occur at any time, sometimes without provocation, and that one may suddenly be put outside the protection of legal process.*[12]

This passage appeared in Dollard's study of the social psychology of Southern race relations, *Caste and Class in a Southern Town*, published in 1937, when anti-lynching legislation was

in the process of being considered by Congress. It was no less applicable in 1939, when Post Wolcott made this photograph, and it continued to be relevant in 1940, when she read Dollard's book and recommended it in a letter to Stryker.

While Post Wolcott continued to pursue issues that she found to be personally compelling between 1938 and 1940, Stryker was more concerned with her documentation of federally funded rural rehabilitation projects. Because she had valuable experience as a news photographer, she was frequently assigned routine work for other government offices such as the Public Health, Soil Conservation and Federal Surplus Commodities agencies. Post Wolcott justly resented the work schedule she was given, since Stryker permitted several other photographers considerable leeway to explore and document general topics of sociological interest. On one occasion, in a June 1940 letter, Post Wolcott complained that she felt pigeon-holed as "the project-photographer-in-chief." No copy of Stryker's reply exists, but it was evidently an effective response. Post Wolcott's next letter was apologetic for having asserted herself in this fashion. Having retracted her grievance, Post Wolcott continued to be dispatched on a hectic succession of government jobs. She also remained frustrated by the way Stryker still practiced a division of labor, although following this exchange, she kept her complaints on this score to herself.

It is not hard to comprehend why Stryker assigned Post Wolcott a disproportionate share of routine government publicity work. Another photographer, Russell Lee, enjoyed far greater freedom in choosing his own subjects and determining his own work schedule, and Stryker's reasons for his trust in Lee's judgment were included in Nancy Wood's essay in *In This Proud Land.*

> *When his photographs would come in, I always felt that Russell was saying, "Now here is a fellow who is having a hard time, but with a little help he's going to be all right." And that's what gave me courage.*[13]

From Stryker's perspective, Lee's photography accorded perfectly with the optimistic liberal rhetoric of the New Deal, exemplified by FDR's memorable phrase, "the only thing we have to fear is fear itself."

By way of contrast, when Post Wolcott was given the opportunity to photograph more freely, the work she produced did not always inspire the same kind of faith in the efficacy of New Deal reforms. While Post Wolcott did indeed produce pastoral views very skillfully, sometimes specifically at Stryker's request (PLATE 14), in a candid passage of her January 21, 1940, letter to Stryker she referred to such work as "FSA cheesecake." In both her manner and her photography, there was a rebellious strain which Stryker must have found unnerving.

In retrospect, it is hard not to wonder if Post Wolcott might have produced a more extensive body of critical FSA photographs had she been given more freedom by Stryker, and had she been less willing to yield to his objectives and to his many requests for FSA project records. One would like to think that such an option was available, although it probably was not. Post Wolcott had been hired at a time when Dorothea Lange was being dropped from the staff, after Lange had made numerous decisions and proposals which Stryker viewed as counter-productive. Significantly, when Lange's relationship with Stryker was already deteriorating, she expressed a personal interest in studying either the special

plight of black tenant farmers or the more urban areas of California. In a letter to Lange, Stryker responded negatively to both proposals, reminding her that the media would take more interest in reports on white tenant farmers, and that public health jobs had a higher priority than the documentation of general urban conditions.[14] It is unlikely that Stryker would have tolerated for long a second woman who exhibited a similar degree of independence.

Post Wolcott, in any case, believed that her job would last only as long as she remained a "team player." Her caption for the Wendell, North Carolina, sidewalk scene, directing attention to the advertisement rather than the pedestrians, was symptomatic of the way she masked her own astute perceptions. Yet she did not censor herself completely. Her most fiercely critical tendencies surfaced in countless letters in which she would momentarily rail against the moralism of social workers, the bungling ineptitude of FSA regional bureaucrats and the complacency of the middle classes. This same critical spirit informed many of her FSA photographs, particularly those she made knowing they might not immediately appeal to Stryker. Indeed, many of her strongest images were buried in the file, and as such, were ineffectual commentaries in terms of the impact they had at the time. Fifty years later, however, the most distinctive photographs by Post Wolcott challenge us far more than many of the typical FSA images that have been widely circulated. They prompt us to consider what other avenues might have been pursued by a 1930s documentary project. No less importantly, they provide us with succinct, though fragmentary, insights regarding some of the issues that were not directly addressed by the New Deal, and that remain in large measure unresolved today.

NOTES

1. For an exhaustive index of recent literature on FSA photography, see Penelope Dixon, *The Photographers of the Farm Security Administration: An Annotated Bibliography, 1903-1980.* (New York: Garland, 1983).

2. Roy Emerson Stryker, "The FSA Collection of Photographs," in Stryker and Nancy Wood, *In This Proud Land* (Greenwich, Connecticut: New York Graphic Society, 1973), p. 8.

3. Ben Shahn photograph reproduced in Stryker and Wood, p. 29.

4. Ben Shahn photograph reproduced in Hank O'Neal, *A Vision Shared* (New York: St. Martin's Press, 1976), p. 47.

5. Dorothea Lange photograph reproduced in Dorothea Lange, *Photographs of a Lifetime* (Millerton, New York: Aperture, 1983), p. 85.

6. The passage appears in Warren Susman's discussion of the rhetoric employed in the 1930s to publicize the recently restored colonial planter's capital at Williamsburg, in Warren Susman, ed., *Culture and Commitment: 1929-1945* (New York: George Braziller, 1973), p. 6.

7. Dorothea Lange photograph reproduced in Dorothea Lange and Paul Schuster Taylor, *An American Exodus* (New Haven: Yale, 1969), p. 20.

8. The *Fortune* article is cited in Arthur F. Raper and Ira De A. Reid, *Sharecroppers All* (Chapel Hill: North Carolina, 1941), p. 108; see also Lois Scharf's discussion of "The Forgotten Woman" in her recent study, *To Work and To Wed: Female Employment, Feminism, and the Great Depression* (Westport: Greenwood, 1980), pp. 110-138.

9. The letters between Marion Post Wolcott and Roy Stryker quoted here are from the collection of Stryker correspondence held by the University of Louisville Photographic Archive, Louisville, Kentucky. The specific dates attributed to some letters were drawn from later annotations by Post Wolcott or other researchers.

10. George B. Tindall, *The Emergence of the New South: 1913-1945* (Baton Rouge: Louisiana State, 1967), p. 555. William E. Leuchtenberg makes a similar assessment in *Franklin D. Roosevelt and the New Deal* (New York: Harper, 1963), pp. 185-186. For a more sympathetic interpretation of Roosevelt's record on racial issues, see Arthur Schlesinger's third volume of *The Age of Roosevelt, The Politics of Upheaval* (Cambridge, Massachusetts: Riverside Press, 1960), pp. 425-438.

11. Tindall, p. 551. For another discussion of the impact of the Association of Southern Women for the Prevention of Lynching, see Gerda Lerner, *The Majority Finds Its Past* (New York: Oxford, 1979), pp. 110-111. For a study that focuses upon the Association's leader, see Jacquelyn Dowd Hall, *Revolt Against Chivalry: Jesse Daniel Ames and the Women's Campaign Against Lynching* (New York: Columbia, 1979).

12. John Dollard, *Caste and Class in a Southern Town* (New York: Doubleday, 1957), p. 331.

13. Stryker and Wood, p. 14.

14. See the exchange of letters between Stryker and Lange dated June 18, 1937 (from Stryker) and June 23, 1937 (from Lange) as well as their correspondence during October 1938; Stryker correspondence, University of Louisville.

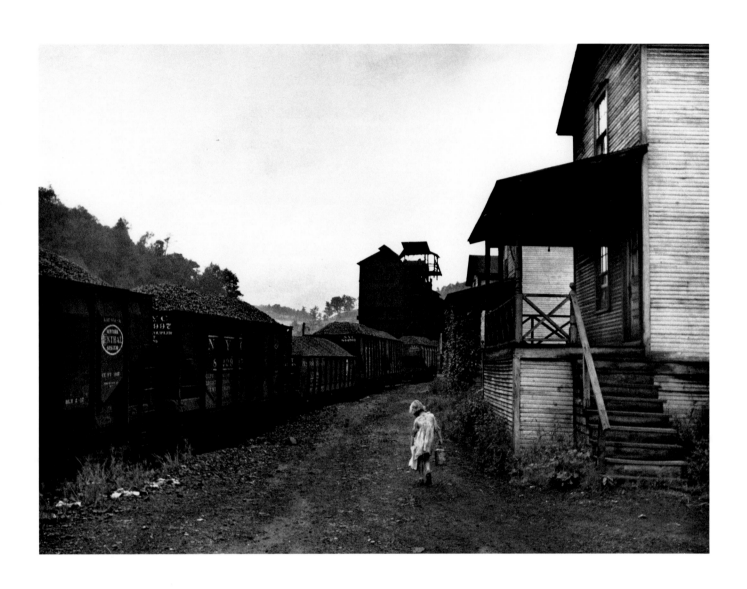

Coal miner's child carrying home a can of kerosene, Scotts Run, West Virginia, 1938 PLATE 1

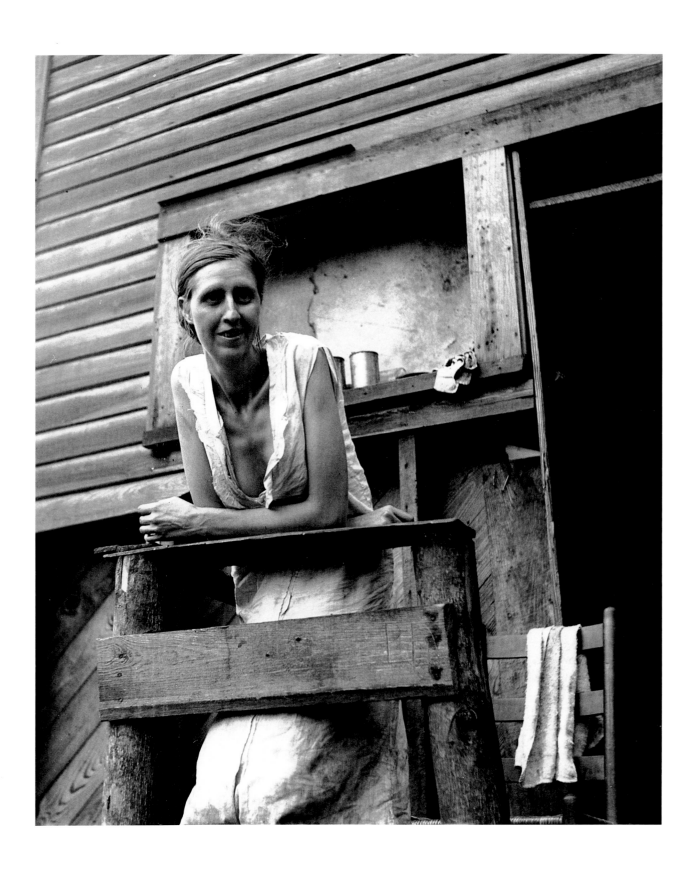

PLATE 2 *Unemployed miner's wife, on porch of company house, Marine, West Virginia, 1938*

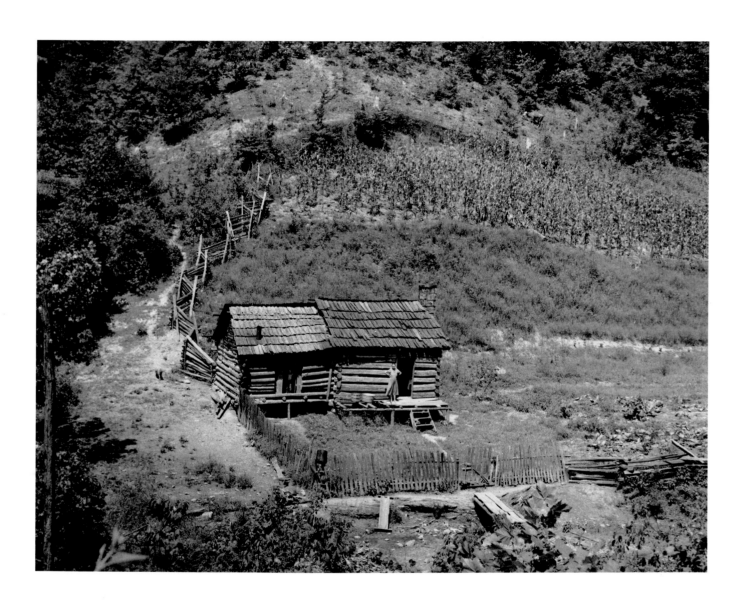

Log cabin by creek in Appalachian Mountains, Tennessee, 1940 PLATE 3

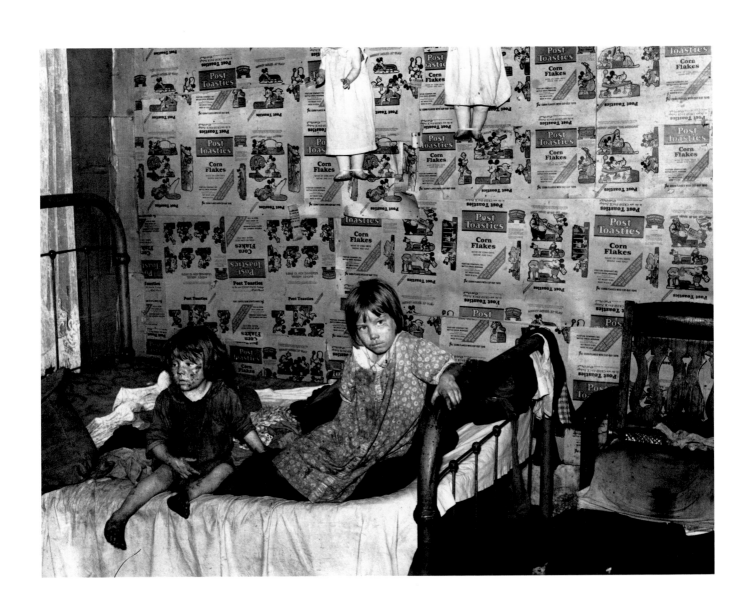

PLATE 4 *Coal miners' children in their shack; no water, sanitary facilities or electricity, Charleston, West Virginia, 1938*

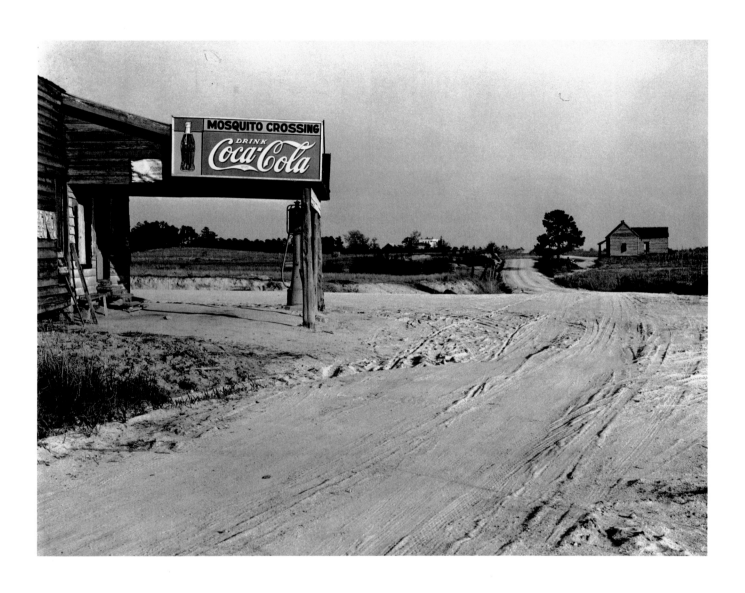

Mosquito Crossing, Greene County, near Greenesboro, Georgia, 1939 PLATE 5

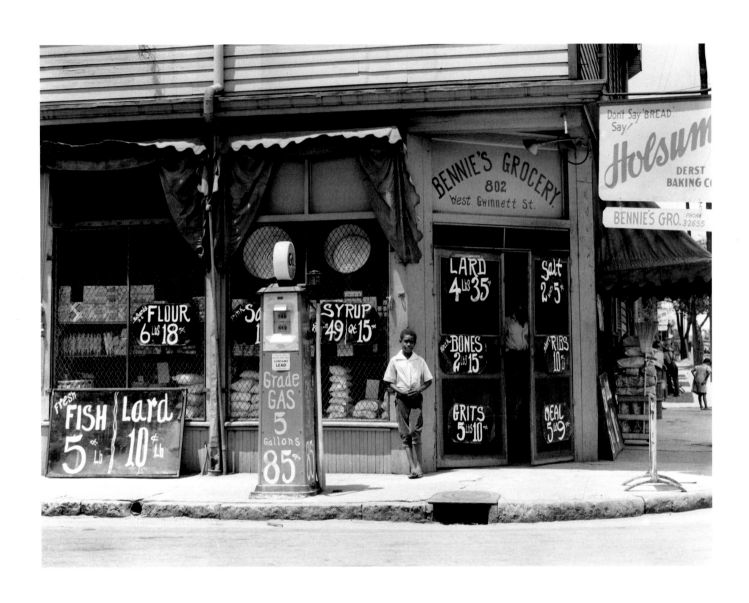

PLATE 6 *Bennie's grocery, in Negro area of town, Sylvania, Georgia, 1939*

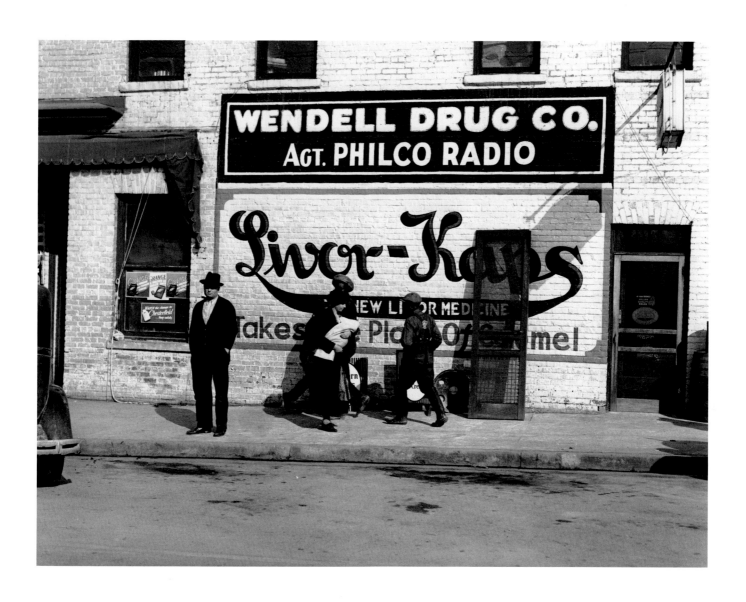

Advertisement on the side of a drug store, Wendell, North Carolina, 1939 PLATE 7

PLATE 8 *Business managers paying off cotton picker, Marcella Plantation, Mileston, Mississippi, 1939*

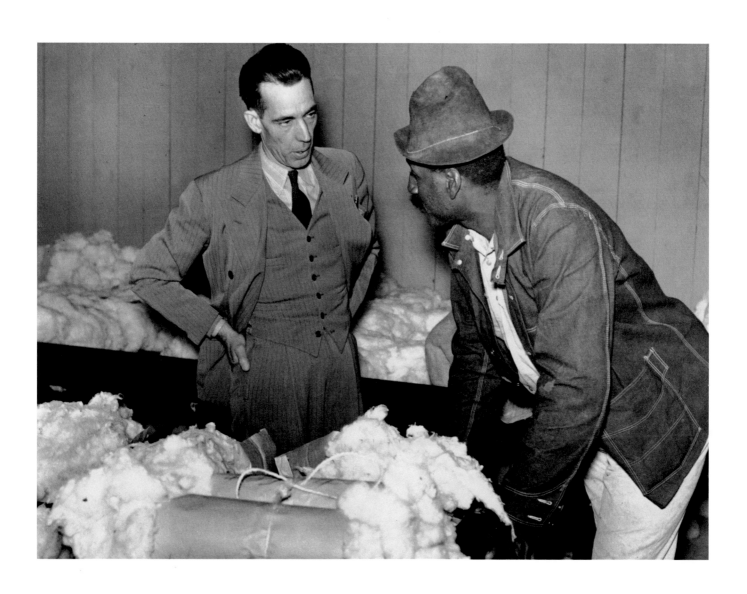

Sharecropper negotiating price of his cotton with cotton broker, Clarksdale, Mississippi, 1939 PLATE 9

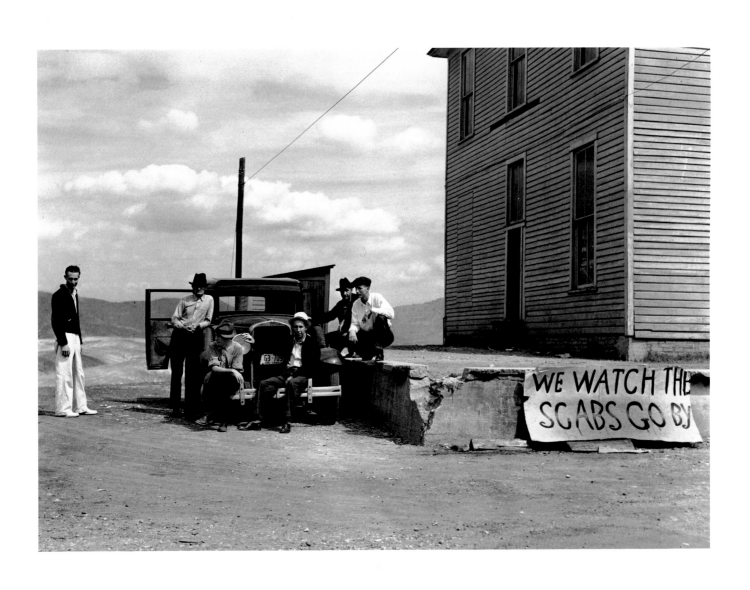

PLATE 10 *Waiting for strike-breakers to come out of copper mines, Ducktown, Tennessee, 1939*

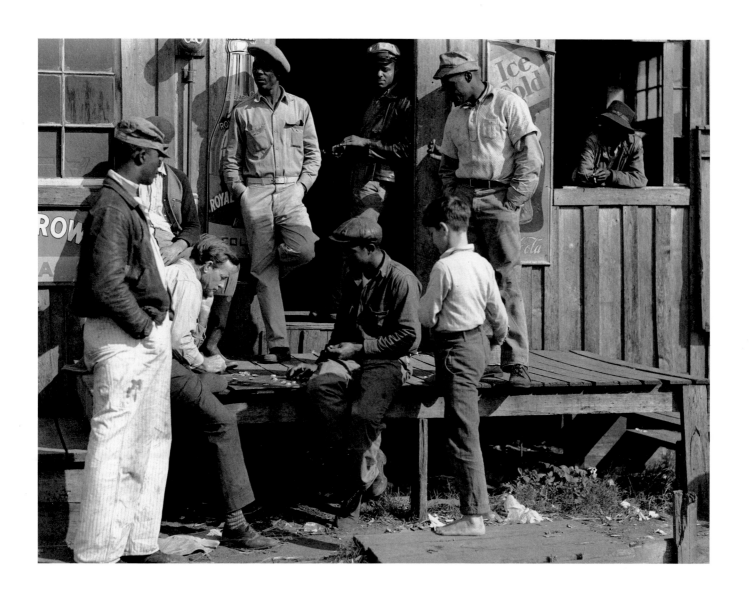

Men playing checkers on porch, Florida, 1939 PLATE II

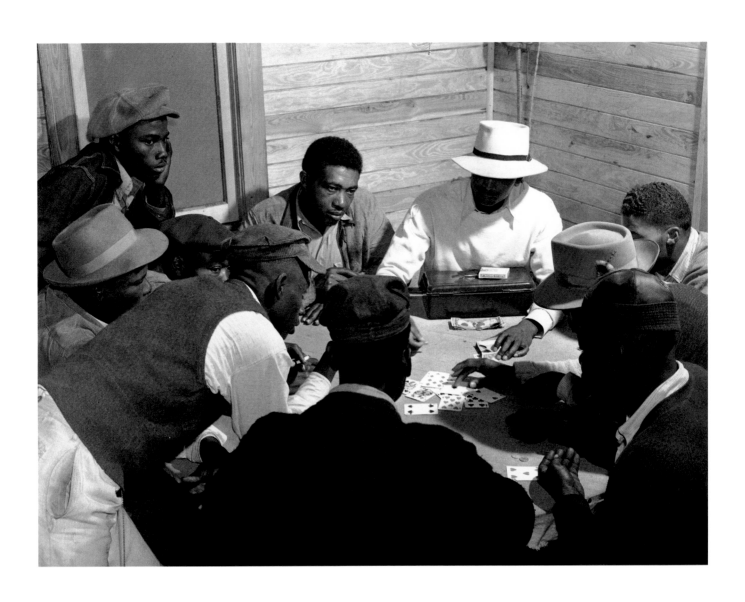

PLATE 12 *Gambling (skin game) in juke joint on Saturday night, near Moore Haven, Florida, 1941*

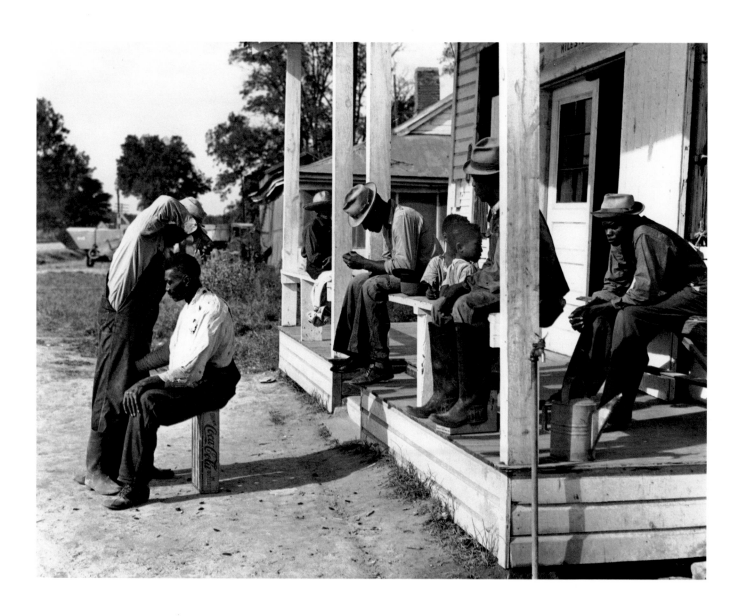

Haircutting in front of general store on Saturday afternoon, Marcella Plantation, Mileston, Mississipi, 1939 PLATE 13

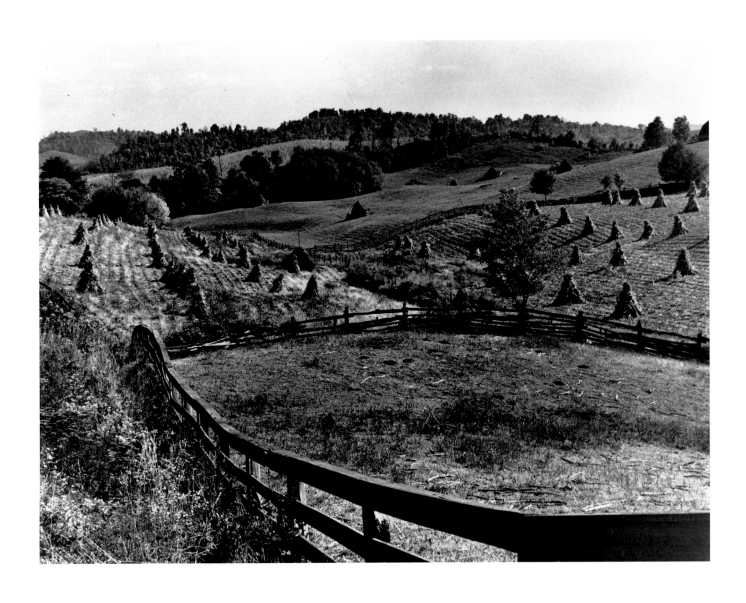

PLATE 14 *Fields of shucked corn near Marion, West Virginia, 1940*

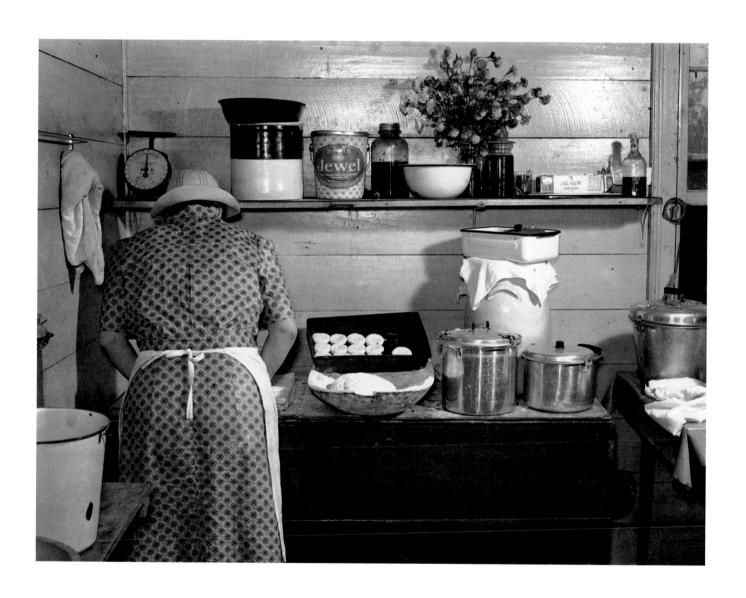

A member of Wilkins family making biscuits on corn-husking day, Tallyho, North Carolina, 1939 PLATE 15

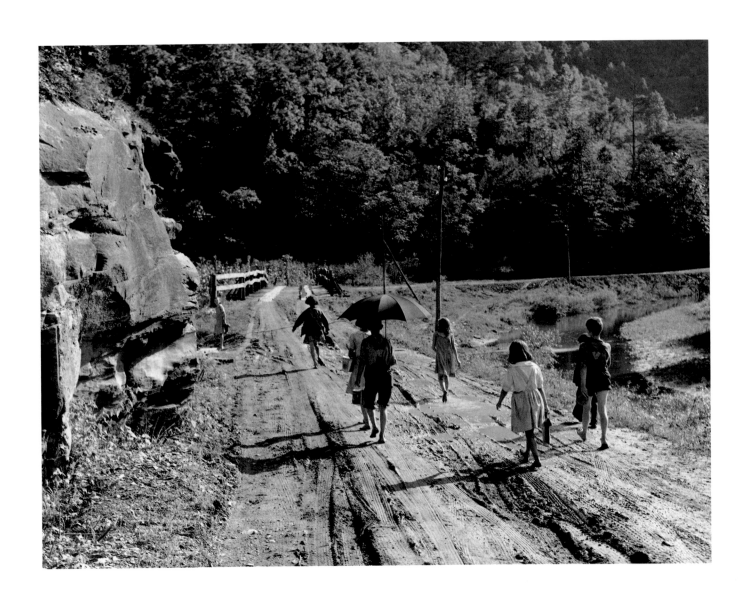

PLATE 16 *Children going to school, Breathitt County, Kentucky, 1940*

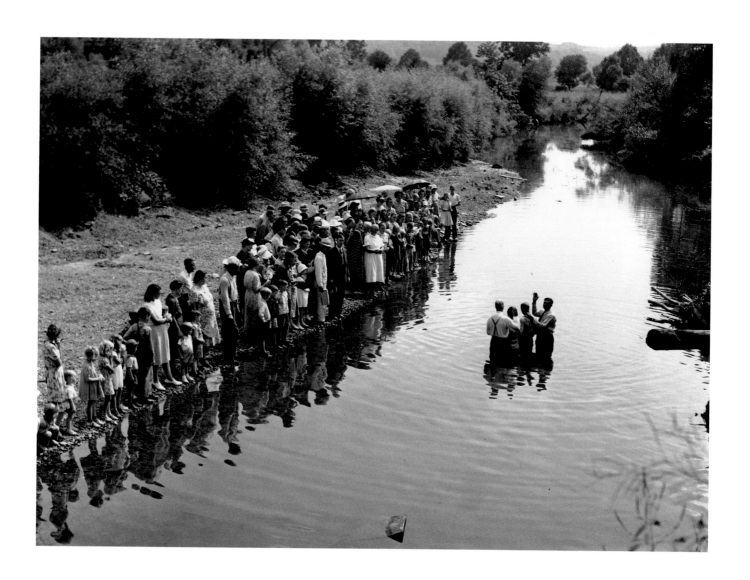

Baptism of members of Primitive Baptist church in Triplett Creek, Rowan County, near Morehead, Kentucky, 1940 PLATE 17

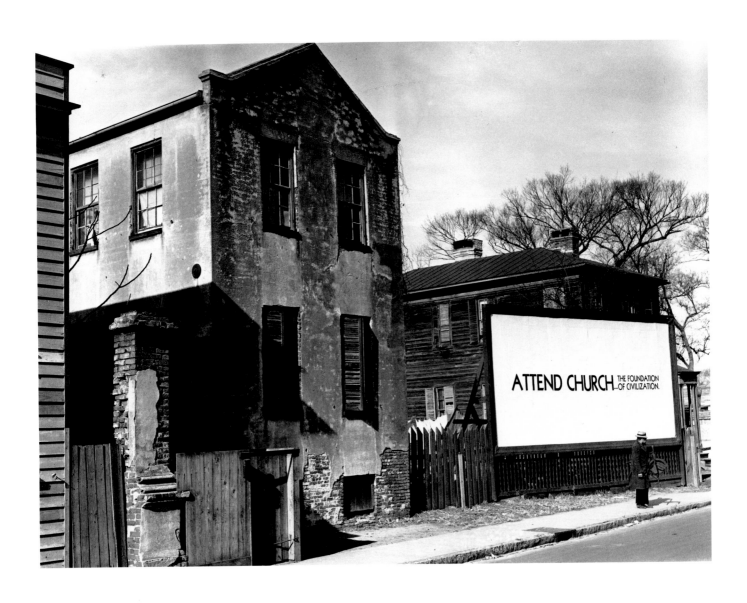

PLATE 18 *Street scene with a church sign, Charleston, South Carolina, 1938*

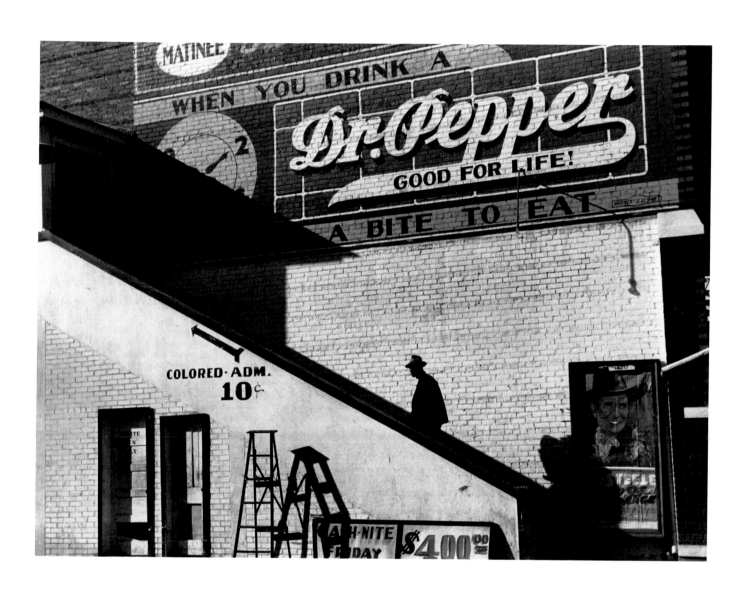

Negro entering movie theater by outside entrance to upstairs colored section, Belzoni, Mississippi, 1939 PLATE 19

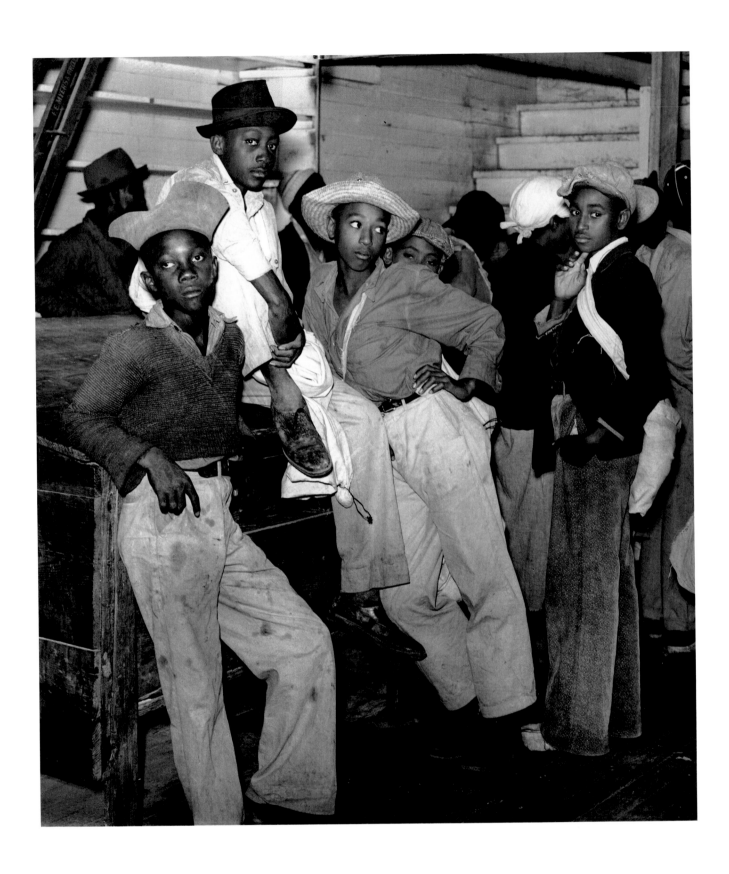

PLATE 20 *Negro boys waiting inside plantation store to be paid for picking cotton, Marcella Plantation, Mileston,*
Mississippi, 1939

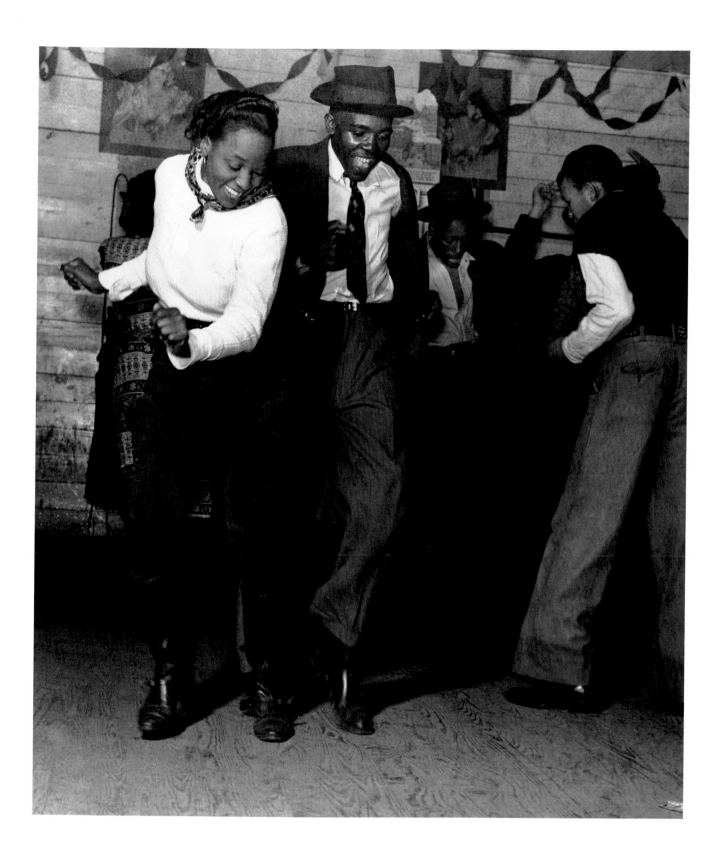

Jitterbugging on a Saturday night in juke joint near Clarksdale, Mississippi, 1939 PLATE 21

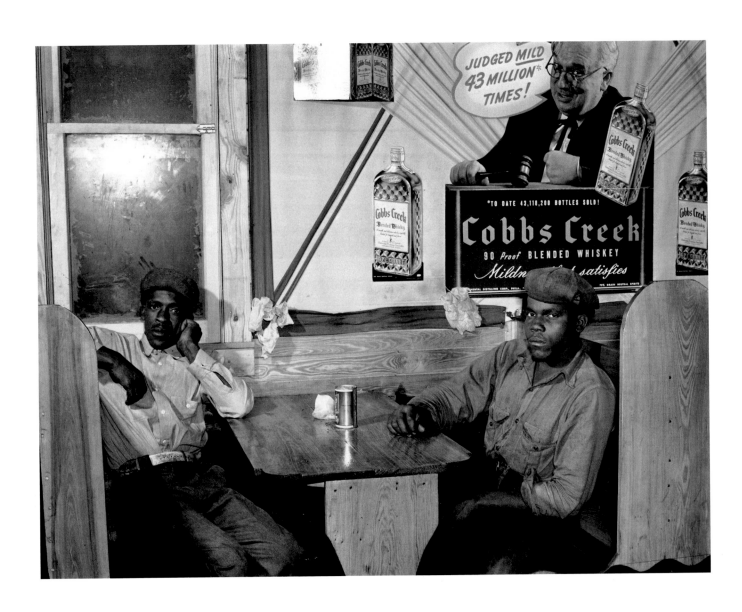

PLATE 22 *Two men from a cotton plantation in a juke joint near Clarksdale, Mississippi, 1939*

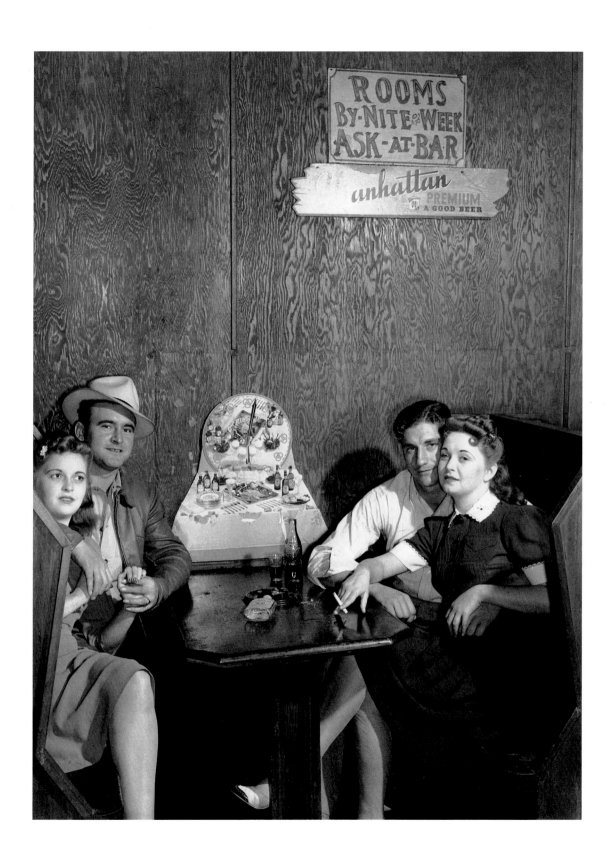

Two young couples in a juke joint, near Moore Haven, Florida, 1939 PLATE 23

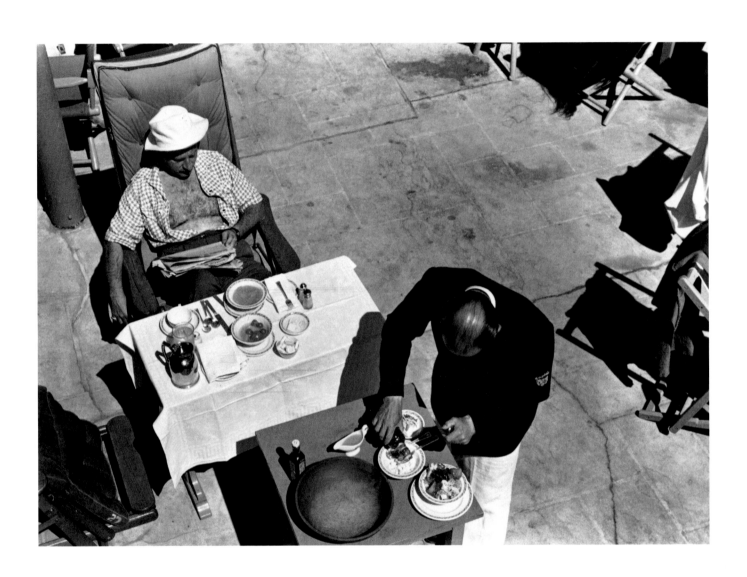

PLATE 24 *Winter visitor being served brunch in a private club, Miami, Florida, 1939*

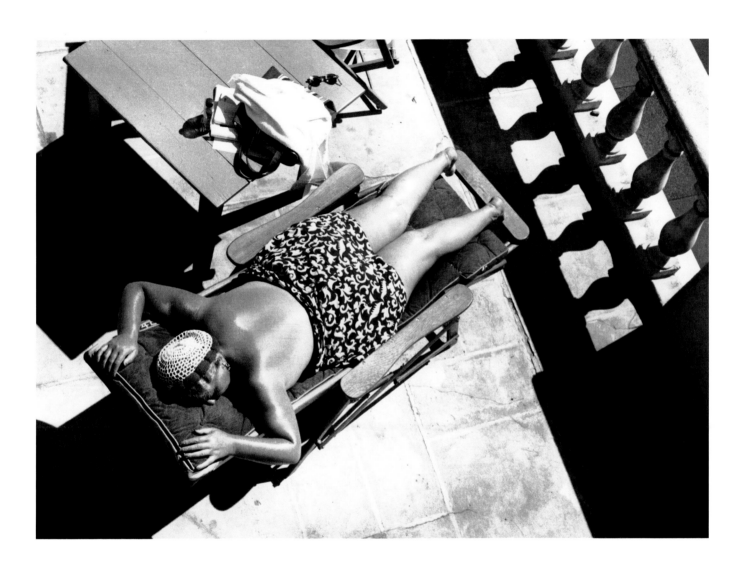

Woman lying in the sun, Miami Beach, Florida, 1939 PLATE 25

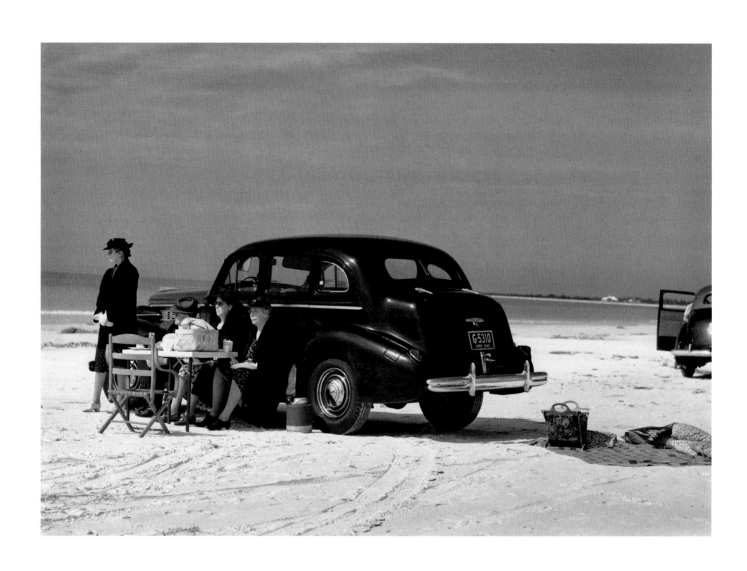

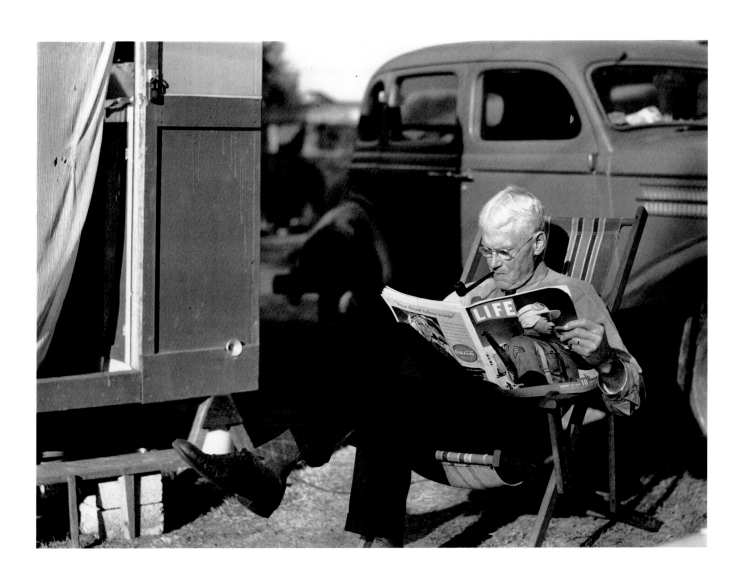

Man reading Life Magazine *behind his car in trailer park, Sarasota, Florida, 1941* PLATE 27

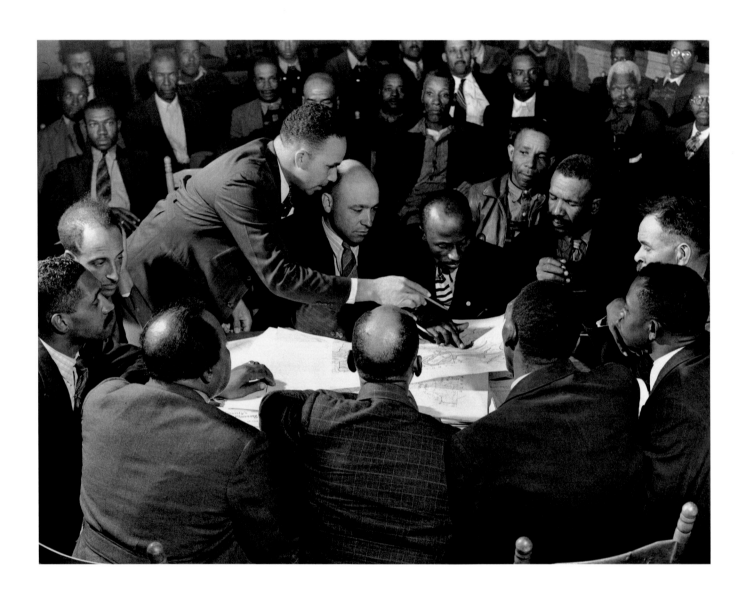

PLATE 28 *Meeting of the Colored County Land Use Planning Committee to work on county maps, in school house,*
Yanceyville, North Carolina, 1940

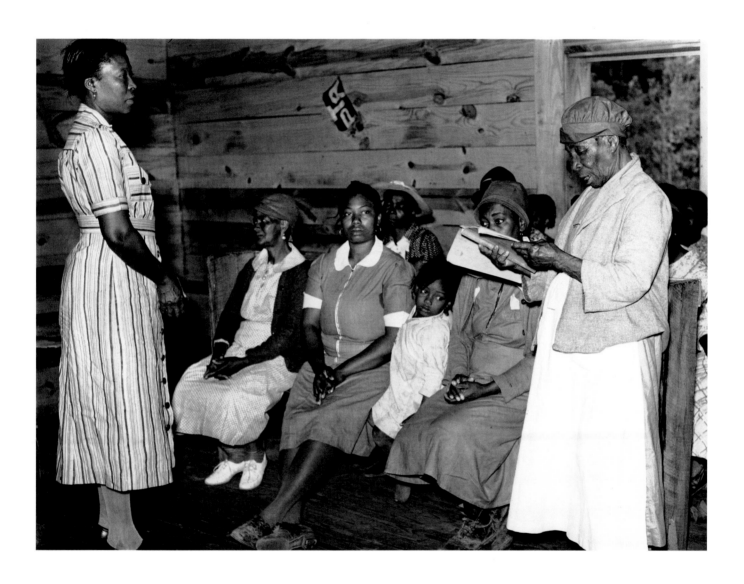

82-year-old woman reading in literacy class, FSA project, Gee's Bend, Alabama, 1939 PLATE 29

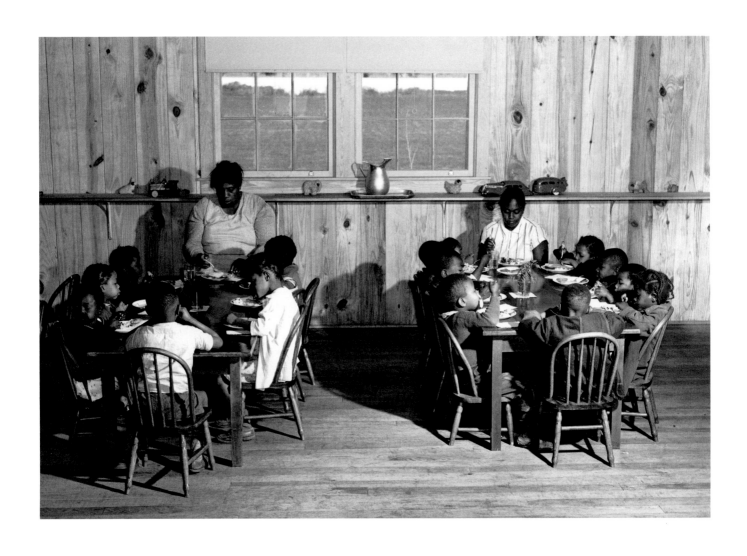

PLATE 30 *Hot lunch in day-care center in new FSA project community building, Okeechobee migrant labor camp, Belle Glade, Florida, 1941*

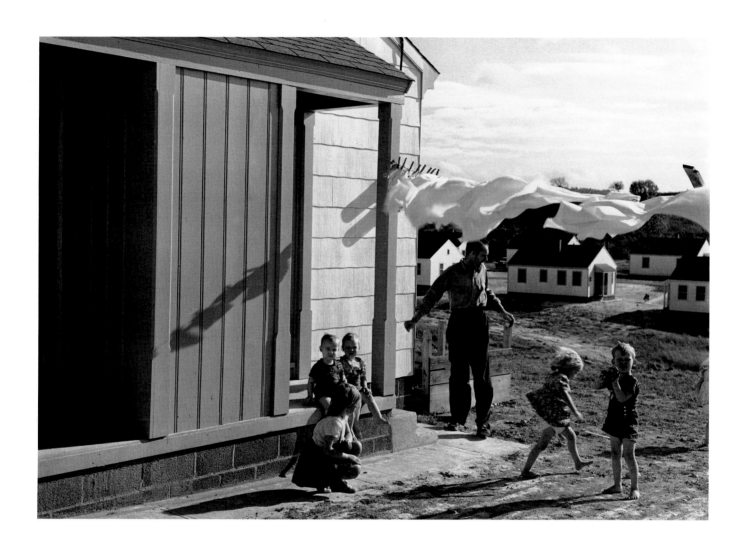

Defense worker's home in FSA housing project, Sunset Village, Radford, Virginia, 1941 PLATE 31

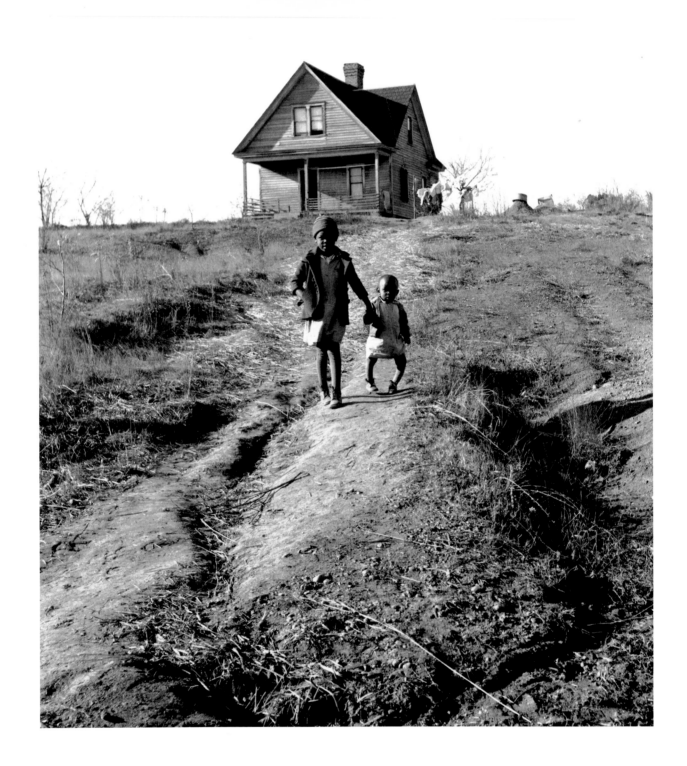

PLATE 32 *Tenant farmer's children, younger one with rickets from malnutrition. Poor, eroded land the result of cotton-tobacco culture. Wadesboro, North Carolina, 1939*

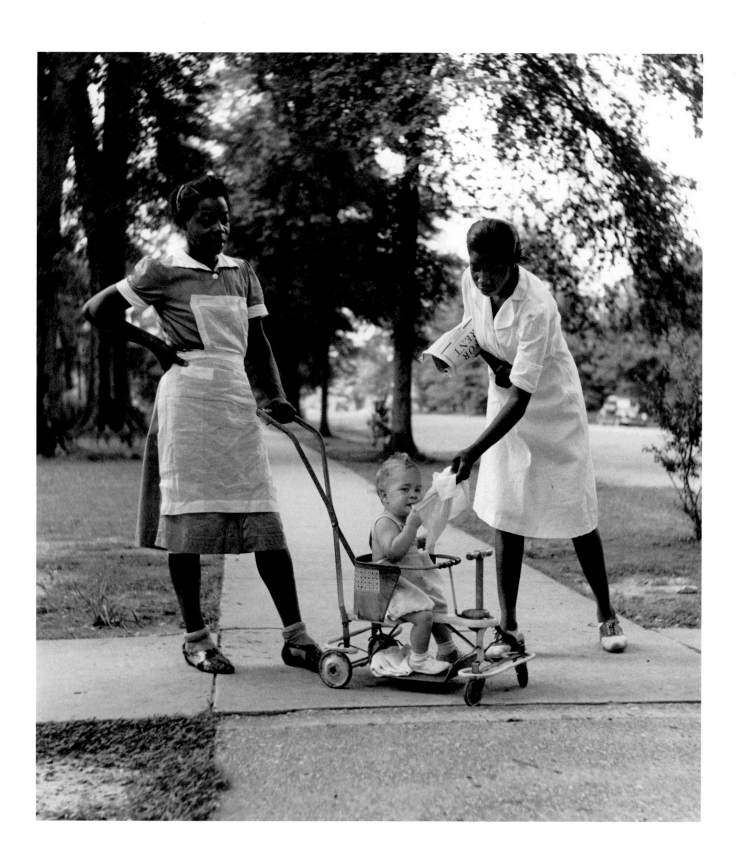

Two colored maids on a street corner with white child in stroller, Port Gibson, Mississippi, 1940 PLATE 33

Chronology & Correspondence

1910

Marion Post born in Montclair, New Jersey.

1931

Post lives in Whitinsville, Massachusetts, a mill town, where she teaches elementary school and rents a room in a boarding house with single mill workers. This experience first introduces her to social and class distinctions in the United States.

1934-1935

Studies at New York University, the New School for Social Research and the University of Vienna, Austria. In Berlin, she hears Hitler speak at a rally and witnesses the build-up of Nazi fervor throughout Germany and Austria. In this social climate, she becomes a vehement anti-Nazi. Returns to New York where she begins studies of photography with Ralph Steiner. She is strongly influenced by her renewed contact with her mother, a political activist concerned with the dissemination of information on birth control for women, and much concerned about the limitations on social workers.

1935-1936

Freelance photographer in New York City, working for the Associated Press and for such periodicals as *Fortune*. Staff photographer, Philadelphia Evening Bulletin. Seeking more interesting work, she consults Ralph Steiner, who was the first to bring a portfolio of her work to the attention of Roy Stryker, Director of the Historical Section of the Farm Security Administration, the founder and moving spirit of the photographic project.

1938

Begins work as staff photographer, Farm Security Administration. Paul Strand writes to FSA director Roy Stryker on June 20, 1938:

> *Dear Roy,*
> *It gives me pleasure to give this note of introduction to Marion Post because I know her work well. She is a young photographer of considerable experience who has made a number of very good photographs on social themes in the South and elsewhere. . . . I feel that if you have any place for a conscientious and talented photographer you will do well to give her an opportunity.*

On July 14, 1938, Stryker writes to Marion Post outlining her initial working arrangements:

> *You will start at $2300 a year, with $5.00 a day expenses for the time you are in the field, away from Washington. You will receive 4½ cents a mile when you travel in your own car. This is to pay gasoline, oil and a certain amount of depreciation. We supply*

you with film, flashbulbs, and some equipment. If you desire a special camera, or cameras, I am afraid you will have to supply it at the present time ... It is our desire to standardize as far as possible on the Leica Contax, and 3¼ x 4¼ Speed Graphic ... I'm glad that you have learned you can't depend on the wiles of femininity when you are in the wilds of the South. Colorful bandanas and brightly colored dresses, etc. aren't part of our photographers' equipment. The closer you get to what the great back-country recognizes as the normal dress for women, the better you are going to succeed as a photographer. I know this will probably make you mad, but I can tell you another thing—that slacks aren't part of your attire when you are in the back-country. You are a woman, and 'a woman can't never be a man.'

Post replies to Stryker:

Now Grandfather—you listen to me for a minute, too. All you say is perfectly true, but—I just wish you had been along with me for just part of the day looking for something, particularly with POCKETS. Let us agree that all photographers need pockets—badly—and that female photographers look slightly conspicuous and strange with too many film pack magazines and rolls and synchronizers stuffed in their shirt fronts, and that too many filters and whatnots held between the teeth prevent one from asking many necessary questions. Now—this article of clothing with large pockets must also be cool, washable, not too light or bright a color. Try and find it! You can see you touched on a sore subject. About slacks—you can't make me mad. I learned you can't wear them in the stix when I was in Tennessee, etc., a couple of years ago—but Florida, in most sections, is an exception. Especially picking, and if you'd seen the results of the pleasant feast the insects and briars and sticker grasses had on my legs the first day you'd know why. Wore a skirt and heavy stockings and socks, and was still a mess. And I DIDN'T use feminine wiles, and I usually wore an old jacket and sweater, but it was too cold that day. My slacks are dark blue, old, dirty, and not too tight—to be worn with great discrimination, sir.

The summer and winter of 1938 Post spends in the Southeast, primarily in such places as Homestead and Belle Glade, Florida.

1939

Spring in Georgia. Summer and fall in North and South Carolina. Post writes in July:

Driving at night is definitely not a good idea for a gal alone in the South. And you know I'm no sissy ... Everything closes up, including gas stations, and everyone goes to bed and the only ones who stay up are bums ... If anything goes wrong you're out of luck and no one understands a girl out alone after dark. The roads are awful and often one must go back and try another way, or walk across the field and muck because the car is too low.

And from North Carolina in October:

I think it is a good place for us to try to work on the use of photography in social research. Good territory because it has several aspects—from the very rural farmland and crops all the way thru the processing and industry ... None of it is very dramatic or startling or stark. Not easy to do.

1940

Winter in Vermont, spring in Tennessee, summer and fall in Louisiana, Kentucky
and Virginia. Post telegrams to Stryker from Vermont:

> *You are a cruel and heartless master. I feel like a Finnish boy scout ... am fingerless,*
> *toeless, noseless, earless. Wish you were here with wind whistling through your britches*
> *too ...*

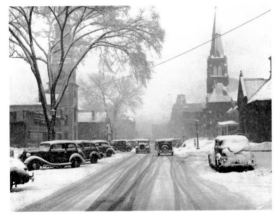

Main street during blizzard, Brattleboro, Vermont,
1940.

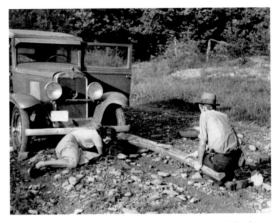

Marion Post Wolcott on assignment on creekbed
road, helping change tire on borrowed car with fence
post as jack, Breathitt County, Kentucky, 1940.

Post writes to Stryker from Tennessee:

> *Mr. White, who launched the cotton stamp program here ... had made <u>no</u> previous*
> *arrangements with the families for me to photograph, so I had to dig them up myself*
> *with the help of the Welfare case workers. The stamp office people and the Welfare staff*
> *were just about crazy, trying to get the whole thing going, and at the same time take care*
> *of the Memphis news photographers, a LIFE photographer who had been <u>very</u> demanding*
> *for two days <u>and</u> newsreel movie guys too ... I had to go out and get the families, scrub*
> *the children, dress them, drag them downtown and then cook their dinner. It was difficult,*
> *and practically impossible to get a man for the pix, as they were either working on W.P.A.*
> *or sick, or drunk, or in the hospital, or refused to do it ... We used a pregnant woman*
> *and when the investigator lady remonstrated her for her bad behavior and 'breaking her*
> *promise to be a good Christian' she said 'well, ma'am, I'se sorry but I had to make my*
> *rent somehow.' Jesus Christ these social workers are fierce, inhuman, stupid prigs. I can't*
> *call them enough names.*

Post writes to Stryker from Louisiana:

> *Several times when I've had the car parked alongside the road and taken pix nearby, a*
> *cop or state trooper has come up, watched me, examined the camera and searched thru*
> *the car, and questioned and looked at all my identification, etc. The bastards can take*
> *their own sweet time about it and ask many irrelevant and sometimes personal and slightly*

impertinent questions too. I've had to visit more than one sheriff's office and write my signature and go thru the same routine, but the worst of it is the time they consume—just chewing the fat with you, making you drink a coca cola, showing you everything in the place. They haven't anything else to do and they don't feel like working anyway—it's too hot, and they think you're crazy anyhow.

Post Wolcott writes from Jackson, Kentucky:

We borrowed a car the first day—had to be pulled out of a creek by a mule, then later hauled out of the sand, and finally had a flat miles from everything and no jack! Tore down a fence post, and while our driver (a young kid who is the son of the school janitor) tried to prop the car up I was down on my belly in the creek bed piling up rocks under it.

1941

Winter in midwest, spring in plains, summer and fall in such western states as Montana, Colorado and Wyoming. Marries Lee Wolcott in June. Post Wolcott writes to Stryker from Montana:

I tried to get the feeling of space, and distance, and solitude, etc., in some pix—using various devices—the road, telephone poles and wires, long trains from up above going straight on as the roads do—and looking across country with trains flat across the picture, very tiny like toys—and telephone signs on posts along the road, and of course little towns and elevators sticking up out of much space.

In the final months of 1941, Post Wolcott writes to Stryker:

It's sort of awful to be separated from someone you love very much ... and keep reading ... that we may be getting close, very rapidly, to the kind of world system that may drastically and perhaps tragically and seriously change our whole lives. There seems to be so little time left to even try to live relatively normally. I get very frightened at times.

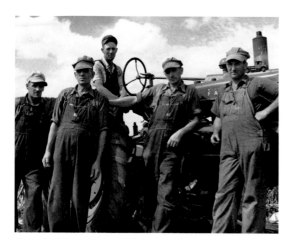

Board of Directors of FSA Two Rivers non-stock cooperative inspecting Farmall tractor, Waterloo, Nebraska, 1941.

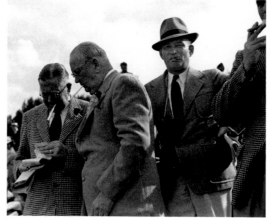

Spectators at horse races, Hialeah Park, Miami, Florida, 1939.

1942

Administration of the Farm Security Administration placed under the jurisdiction of the Office of War Information. Post Wolcott resigns in February, moves to a farm in Virginia to raise a family and collaborate with her husband on management of farm and all future activities.

1954

The Wolcotts move to Albuquerque, New Mexico where Lee Wolcott accepts teaching position at the university. Marion Post Wolcott teaches convalescing Navajo children.

1959

Travels with husband in Foreign Service to Iran, Pakistan, Egypt and India. Post Wolcott teaches in American schools.

1968

Lee Wolcott retires; the couple moves to Santa Barbara, California.

1975

Marion Post Wolcott begins to pursue color photography seriously.

1978

The Wolcotts move to San Francisco and become actively involved in the photographic community there.

1983

Work included in the major exhibition, *FSA Color,* at Light Gallery, New York City. First major monograph published.

The Friends of Photography

The Friends of Photography, founded in 1967, is a not-for-profit membership organization with headquarters in Carmel, California. The programs of The Friends in publications, grants and awards to photographers, exhibitions, workshops and lectures are guided by a commitment to photography as a fine art, and to the discussion of photographic ideas through critical inquiry. The publications of The Friends, the primary benefit received by members of the organization, emphasize contemporary photography yet are also concerned with the criticism and history of the medium. They include a monthly newsletter, a journal and major photographic monographs. Membership is open to everyone. To receive an informational membership brochure, write to the Membership Coordinator, The Friends of Photography, P.O. Box 500, Carmel, California 93921.